LUCY'S EYES AND MARGARET'S DRAGON

LUCY'S EYES AND MARGARET'S DRAGON

The Lives of the Virgin Saints

GISELLE POTTER

CHRONICLE BOOKS

SAN FRANCISCO

For Alice

Printed in Hong Kong.

Library of Congress Cataloging-in-Publication Data:
 Potter, Giselle.
 Lucy's eyes and Margaret's dragon: the lives of the virgin saints /
 by Giselle Potter.
 p. cm.
 ISBN 0-8118-1515-3 (hardcover)
 1. Christian women saints—Biography. 2. Virginity—Religious aspects—
Christianity. I. Title.
BX4656.P67 1997
282'.092'2—dc21
 97-854
 CIP

Book and cover design: Gretchen Scoble

Distributed in Canada by Raincoast Books
8680 Cambie Street
Vancouver, B.C. V6P 6M9

10 9 8 7 6 5 4 3 2 1

Chronicle Books
85 Second Street
San Francisco, CA 94105

Web Site: www.chronbooks.com

CONTENTS

Butterflies in clouds accompanied her standard;
Pigeons miraculously fluttered toward her;
Men fell into rivers and were drowned;
Dead babies yawned and came to life;
Flocks of little birds perched on bushes
to watch her making war.

—VITA SACKVILLE-WEST,

Saint Joan of Arc

INTRODUCTION

HESE ARE THE STORIES of brave women who fought to follow their hearts. Their devotion to virginity may oppose our modern notion about powerful women, but in the world they inhabited, taking a vow of chastity was not a passive act; it was a rebellion against the conventions and men that ruled them. These early saints were not swayed from their ideals or turned away from their goals, even under the threat of violence. They met their fierce punishment with smiling grace rather than fear.

Miraculous events helped the virgins through their battles. They became unmovable, fireproof, and airborne. They lost eyes, breasts, and beauty, and then regained them. Saint Margaret emerged from

a dragon's belly unharmed, and Saint Agnes grew long hair to defend her modesty as she was led naked through the streets to a brothel. During their lives such miracles caused these women to be condemned as witches and heretics; after their deaths, the miracles led to their canonization as saints.

Many texts question the existence of some of these women, but whether they are mythical characters or heroines of history, they still have admirers around the world. Girls wear wreaths of candles on Saint Lucy's day, and eat hard-boiled eggs on the eve of Saint Agnes's feast day so they may dream of future suitors.

These virgin saints are examples of strength and courage for all women. We may take comfort in the thought that they may be watching over us, protecting us from illness, bad eyesight, difficult childbirth, fire, or cumbersome husbands.

SAINT URSULA

PATRONESS OF SCHOOL GIRLS

FEAST DAY : OCTOBER 21

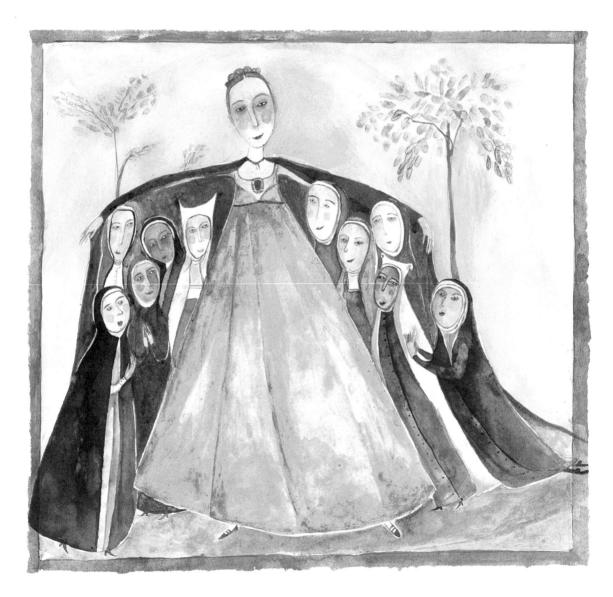

SAINT URSULA

URSULA WAS THE DAUGHTER of the Christian King Nothus of Brittany. When word of her astonishing beauty was brought to the attention of the King of England, a pagan, he was determined that she marry his son. The wily Ursula said she would accept his proposal if he would agree to three small conditions. The first was that he grant her a three-year hiatus in which to practice and celebrate her chastity. The second was that the prince, her betrothed, should spend these same three years becoming a Christian. And her third demand was that the British king provide the necessary boats and supplies to send her with ten virgin companions, each accompanied by one thousand virgin handmaidens, on a pilgrimage to Rome. The King consented, but then died, so his son carried out her wishes.

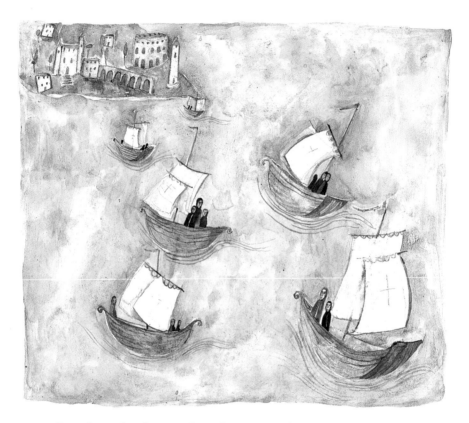

Somehow, the Queen of Sicily, Gersina, heard of Ursula's plans. Gersina had converted her own husband from a wolf to a lamb and was therefore very sympathetic to Ursula's plight. She decided she would help gather virgins for the pilgrimage, including her own four daughters. Eleven thousand virgins convened in the Port of Gaul and sailed to Cologne with angels as their captains. From there, the virgins walked to Rome, where Pope Cyracus baptized them all. On their

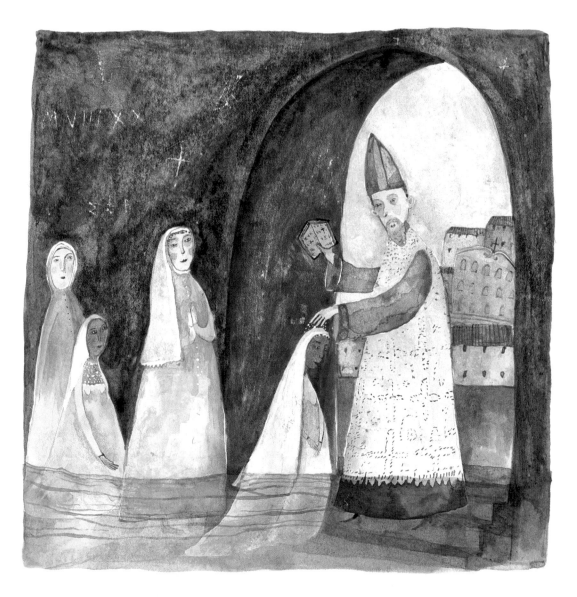

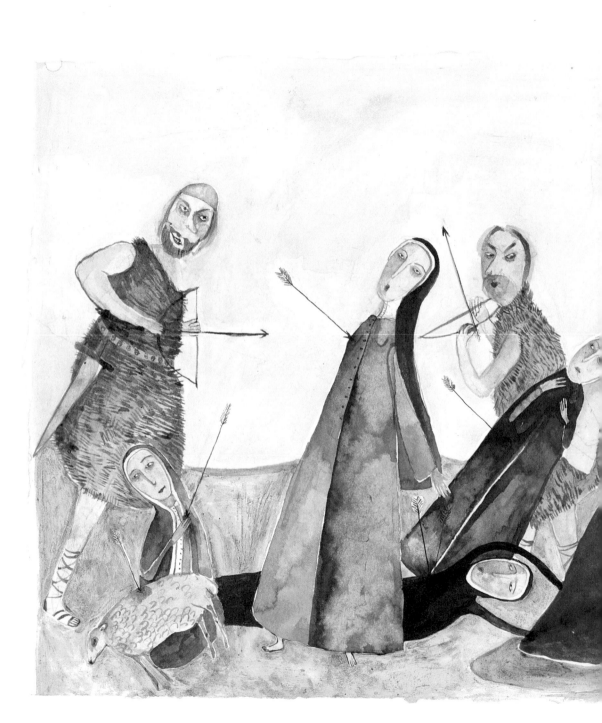

return to Cologne, tragedy befell them. The eleven thousand virgins were attacked by Huns, who shot them all with arrows. When the chief of the Huns stumbled across Ursula, he was dumbfounded by her beauty. Instantly, he offered to make her his wife instead of killing her. Of course, she refused, and his arrow pierced her heart.

On Ursula's feast day, boats are paraded through town on wheeled carts. One of her symbols is a white dove, which was seen resting on her grave.

AGNES

SAIN† AGNES
PATRONESS OF GIRL SCOUTS
FEAST DAY : JANUARY 21

SAINT AGNES

GNES, THE DAUGHTER OF a noble Roman family, had the demeanor of a lamb, one of her symbolic attributes. One day when she was twelve years old, the governor's son, Eutropius, saw her walking home and fell instantly in love. He plied her with expensive gifts, but she accepted nothing. He desperately begged her to marry him. She replied calmly, "I have already chosen a spouse who cannot be seen with mortal eyes and whose mouth drips with milk and honey."

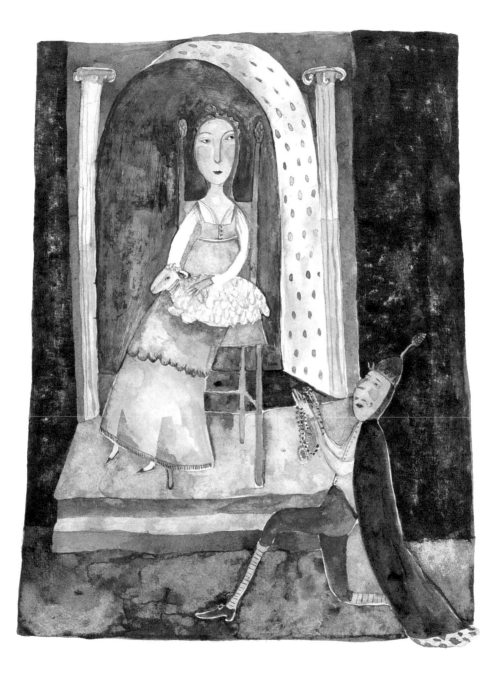

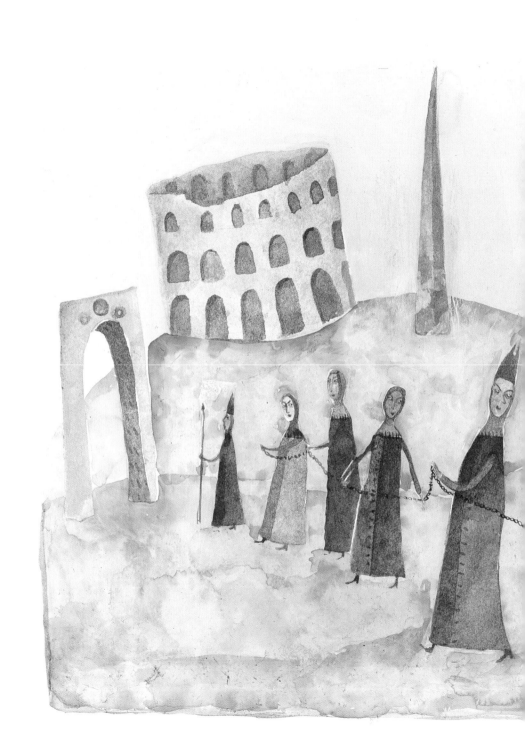

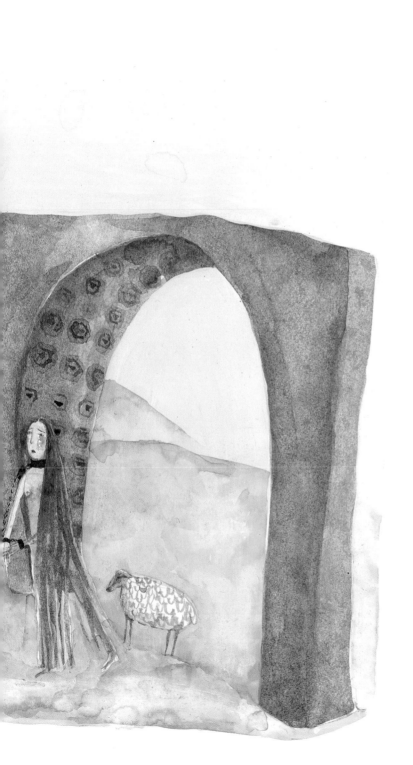

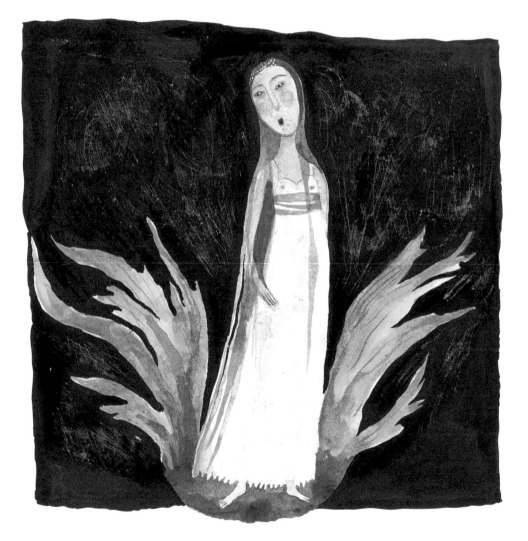

At this, Eutropius was pierced with jealousy and humiliation, and he spent days in bed moaning sadly. When the family doctor diagnosed him as lovesick, Eutropius's father flew into a rage. He stormed to Agnes's home and presented her with two choices: She could either give sacrifices to the goddess Vesta or sacrifice herself in a brothel with the harlots. Agnes would not hear of pagan worship and so was forced to accept the alternative. She was led naked through the streets to the house of ill-fame, but as she walked, her thick golden hair grew miraculously, covering her entire body. When she arrived at the brothel, an angel came to her room and clothed her in a glittering robe. After these signs, no men dared to approach her, except for the love-maddened Eutropius. When his eyes fell on her, he was instantly blinded, but Agnes magnanimously restored his sight. He ungratefully allowed her to be condemned as a witch shortly thereafter; as a punishment, she was tossed into a roaring fire, but the flames parted and Agnes was unharmed. A Roman soldier ended her life at thirteen with a dagger through the throat.

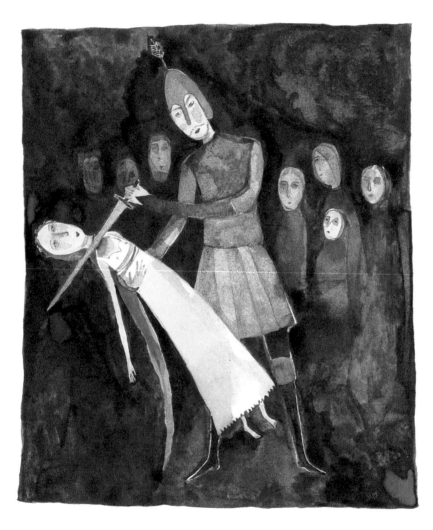

Several years later, Agnes's foster sister, Emerentiana, stood by her tomb. Suddenly, an earthquake and hurricane occurred, killing many Romans. The astonished Emerentiana beheld a vision of Agnes amongst a chorus of angels descending from the stormy sky. Clad in a golden robe and clutching a pure white lamb, Agnes called out to her sister, "Do not mourn my death. Rejoice and be glad with me." Still later, the daughter of the Emperor Constantine, Constantina, who suffered from leprosy, fell asleep at Agnes's tomb and awoke to find herself cured. She had a basilica erected on the site.

Lambs are blessed on Agnes's feast day. A young maiden who fasts on Saint Agnes Eve and then eats a hard-boiled egg at bedtime may dream of her future spouse.

SAINT

CeciLia

PATRONESS OF MUSICIANS

FEAST DAY : NOVEMBER 22

SAINT CECILIA

CECILIA WAS BORN IN the third century to a noble Roman family that secretly practiced the outlawed Christian faith. Her name is derived from the Latin words *ceoli lilia,* meaning lily of Heaven. At the age of six, she displayed precocity and sanctity in her ability to play any musical instrument and to hear the voices of singing angels in accompaniment.

Later, she was unwillingly betrothed to a man named Valerian. She grew more and more miserable as the date of her marriage approached, and, on the eve of the wedding, she wore a horsehair girdle underneath her nuptial gown and sang dirges while playing the organ. Finally, she confessed to Valerian that she had taken a vow of virginity. "There is an angel who watches me and wards off anyone who would touch me," she warned.

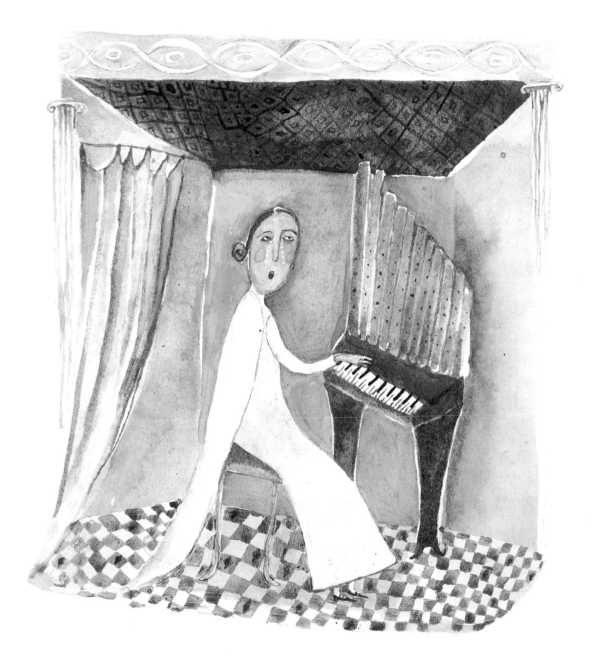

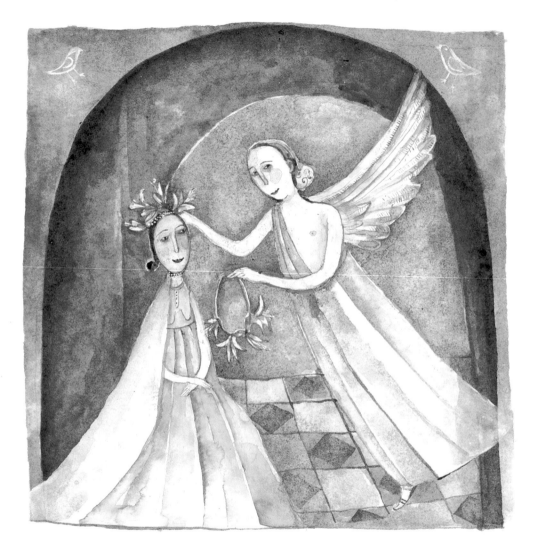

Valerian refused to believe a word of it unless she could show him the angel. Cecilia told him that he would indeed see an angel if he went to be baptized by the Bishop Urban. Grudgingly, Valerian journeyed down the Appian Way to the spot where martyrs were interred, and there he saw an aged man clad in snowy garments carrying a book illuminated in gold. Valerian fainted to the ground, and when he awoke, the holy Bishop Urban baptized him. Transformed, Valerian returned to Cecilia, only to find her conversing with an angel, who crowned the nuptial couple with lilies. Valerian's brother happened upon the scene and was instantly converted. Together, the brothers made daily trips down the Appian Way to bury martyred Christians, but when their occupation was discovered by the pagan authorities, they were both beheaded. Cecilia was soon fingered by the pagans as well; she was told to sacrifice to the pagan idols or die. Undaunted, she chose death; four hundred witnesses wept copious tears and were converted to the faith. Urban baptized them all. The Roman prefect, Almachius, ordered her to be killed in a tub of boiling water. She sat in the bath as if it were cool water and did not shed a drop of perspiration. Furious, Almachius ordered her beheaded, but three blows did not sever her head and to

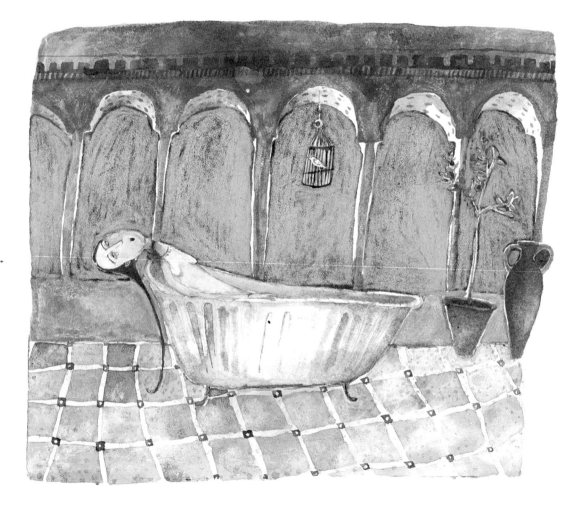

give a fourth would have been contrary to Roman law. Cecilia survived three more days with a half-severed head and managed in that time to give all her possessions to the poor. Crowds collected her blood in sponges and napkins. She died while making the sign of the holy Trinity; her body is buried in the Saint Callista catacombs on the Appian Way and a church was erected in her honor on top of her house in Trastevere.

SAINT✝
AGATHA

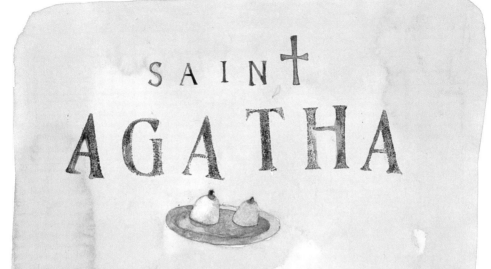

PATRONESS AGAINST BREAST DISEASE
FEAST DAY : FEBRUARY 5

SAINT AGATHA

AGATHA WAS A LOVELY virgin of third-century Catania, Sicily. Quintanius, a Roman senator and worshipper of pagan idols, was awestruck by her beauty and became determined to have his way with her. He had her brought to his palace under guard, but his advances proved futile, for Agatha had consecrated her virginity to God. Quintanius called in Aphrodisia, a notorious harlot, and her nine daughters who also plied the trade, but their attempts to persuade Agatha to join in their activities were, unsurprisingly, useless. Agatha continued to resist Quintanius and gained popular support by her words: "My determination is built on rock, your promises are but raindrops, your threats but rivers, and however hard they beat upon the foundation of my house it cannot fall." Humiliated by her wisdom, Quintanius ordered her to be jailed and tortured. She was stretched

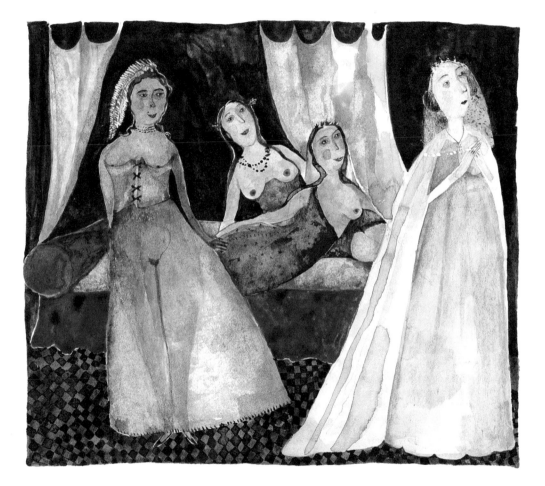

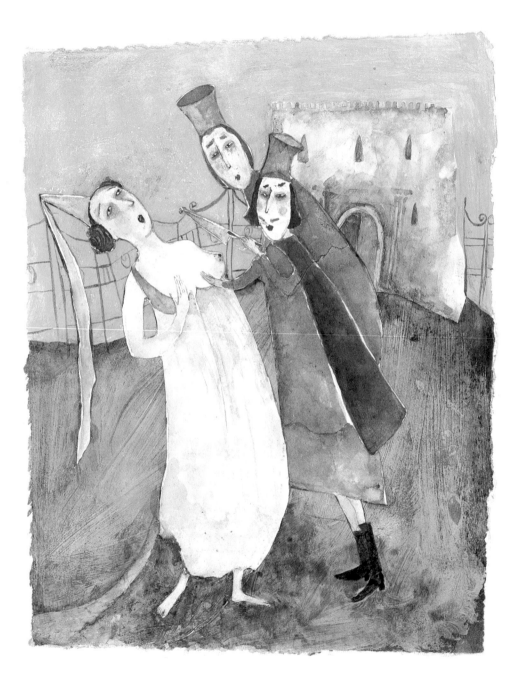

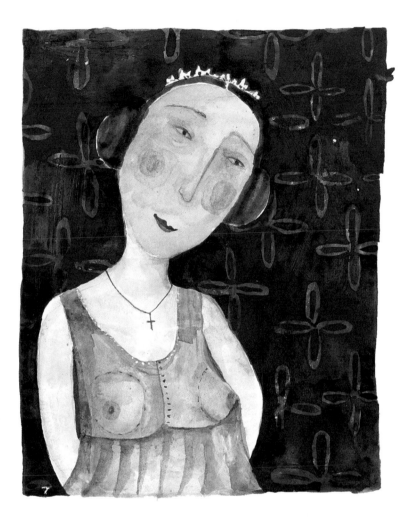

on a rack while soldiers twisted her breasts and then chopped them off. Coolly, she remonstrated, "Are you not ashamed to cut off from a woman that with which your mothers suckled you?"

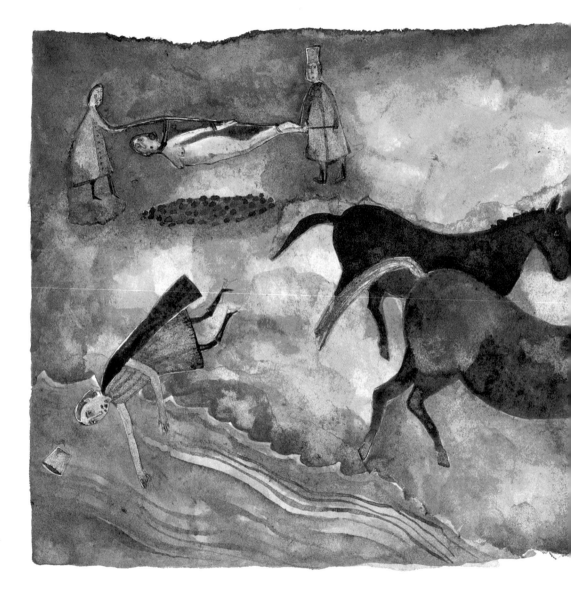

That night, an aged man, who introduced himself as Saint Peter, came to her cell with a celestial ointment that restored her breasts back to her chest. A few days later, Quintanius renewed her torments by ordering her to roll naked over hot coals, but, at the very moment she did so, an earthquake shook the town, killing Quintanius's councilors. Agatha returned to her cell, prayed, and then died. Dozens of Christians visited the prison and anointed her body with spices. Hundreds of beautiful boys in white silken garments brought an alabaster sarcophagus and headstone for the interment of her body. Meanwhile, one of Quintanius's horses bit him and another kicked him into a nearby river. His body was never recovered.

Agatha's most famous relic is her veil, which saved the Catanians from volcanic disaster. When the mountain near Catania erupted, the townspeople waved the veil before the approaching lava, and it halted. Other relics include at least six breasts. In France, Saint

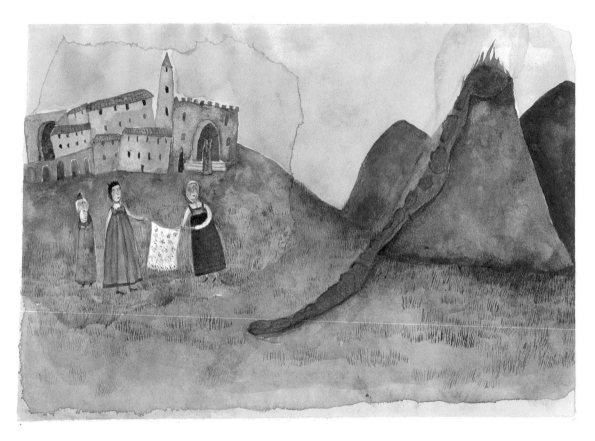

Agatha's feast day is celebrated in a procession preceded by a berib-
boned tree, and by the baking and blessing of loaves of bread shaped
like breasts called "Agathas."

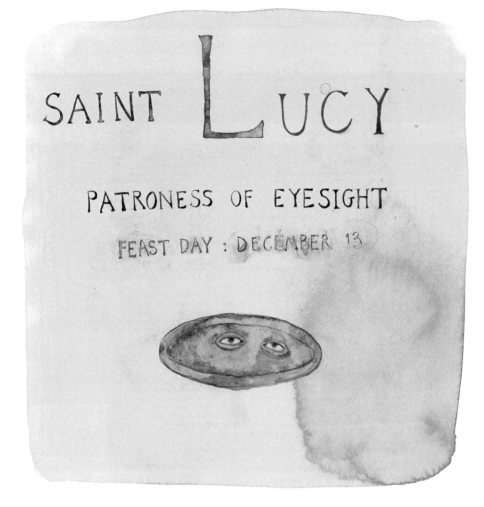

SAINT LUCY

PATRONESS OF EYESIGHT

FEAST DAY : DECEMBER 13

SAINT LUCY

Feast Day: December 13
{PATRONESS OF EYESIGHT}

SAINT LUCY WAS BORN to a family of wealth and
nobility in Syracuse, Sicily, in the late third century. Her
father died when she was an infant, and her mother, Eutychia, became
gravely ill. Most of Lucy's childhood was spent nursing her mother,
but finally, when Eutychia suffered a terrible hemorrhage, Lucy decided
that medical remedies were insufficient and carried the dying woman
to the altar of Saint Agatha in Catania. Lucy fell asleep at the altar
and Saint Agatha appeared to her in a vision, saying, "Virgin Sister,
you need no help. Your faith alone will cure your mother." As Lucy
opened her eyes, she looked to Eutychia's nearly lifeless body and said,
"You are healed." Instantly, Eutychia's suffering ceased.

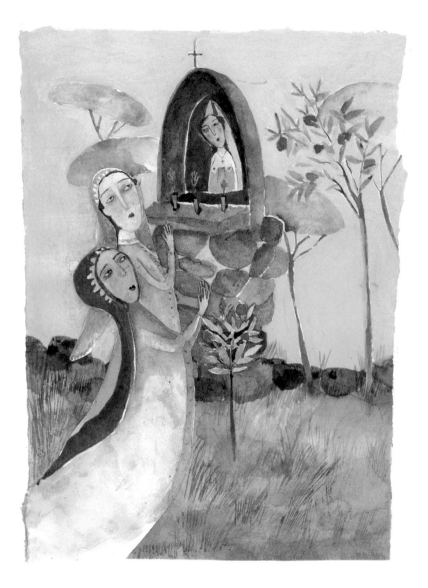

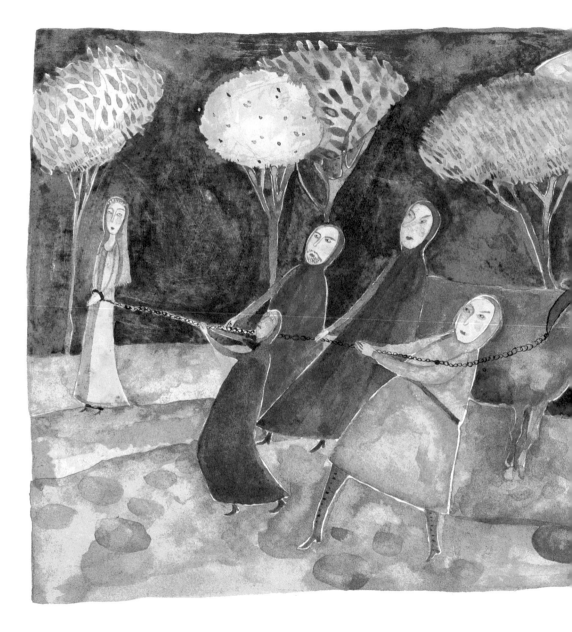

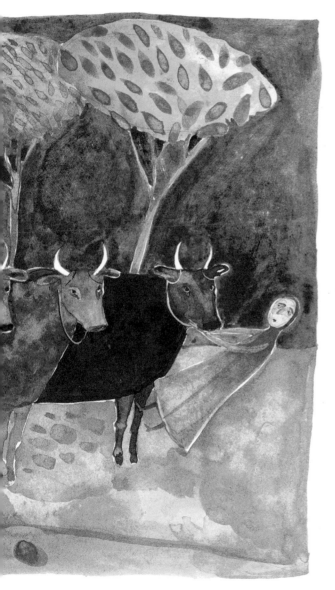

This miraculous recovery converted both mother and daughter to Christianity; they gave all their worldly possessions to the poor, and Lucy took a vow of chastity. Eutychia had always hoped for her daughter to marry and have children, but she gave her blessing to Lucy's vow. However, Paschasius, Lucy's pagan suitor, was not so understanding. He denounced her as a Christian in front of the governor, and she proudly confirmed the accusation.

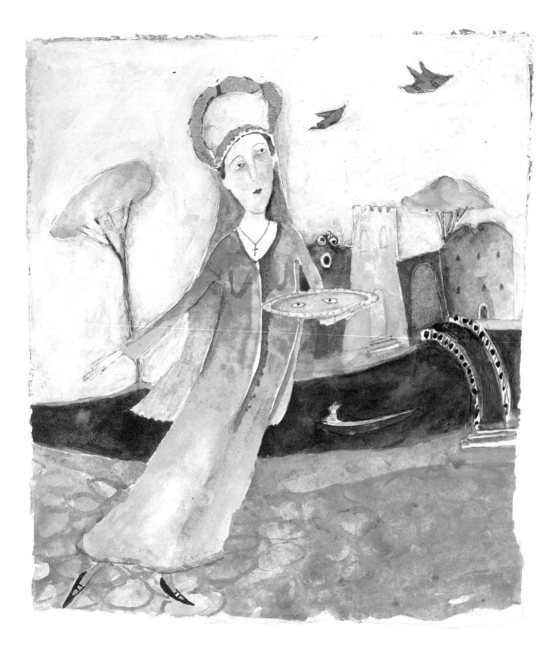

The governor gave her the usual punishment of being condemned to a brothel, but Lucy stood so firm in her faith that one thousand men and a team of oxen couldn't move her. The governor sentenced her to burning, but the flames leapt around her without effect. Enraged, Paschasius put the sword to her throat, but before he could behead her, she plucked out her eyeballs and handed them to him, because he had always admired them. A new pair of eyes, even more beautiful than the first, grew in their place.

Lucy's altars are often adorned with thousands of miniature eyes, and her faithful pray to preserve or gain the gift of sight. In Venice, her name echoes through the canals as gondoliers sing "Santa Lucia." Her name means *light* in Latin; under the Gregorian calendar her feast day fell on the shortest day of the year, the winter solstice. In Sweden on Saint Lucy's Day, the eldest daughters of a household dress in white gowns and wear wreaths of candles upon their heads as they awaken the family with coffee, pastries, and song.

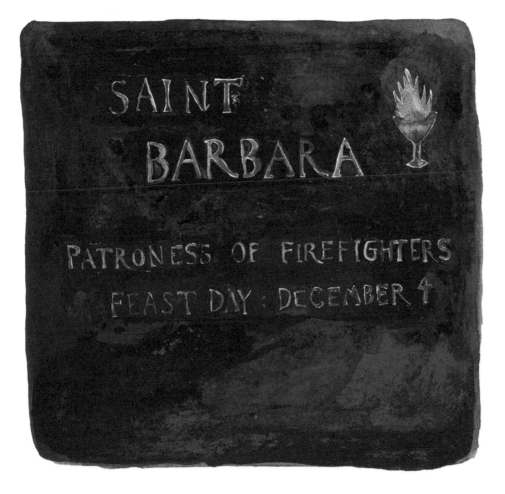

SAINT BARBARA

{PATRONESS OF FIREFIGHTERS, AND AGAINST SUDDEN
DEATH BY STORM AND LIGHTNING}

BARBARA WAS A MAIDEN of third-century Syria. Her bad-tempered father, Dioscurus of Heliopolis, stuck her in a tower so that no man could ever see her and want her. He dug a moat around the tower as further discouragement, but owing to Barbara's virtue, the water of the moat gained special healing powers, and crowds flocked there to be cured.

One day when Dioscurus was away, Barbara asked a carpenter to add a third window to her tower so that she might contemplate the Holy Trinity. He complied, and to complete the room, she made the sign of the cross with her thumb on the stone wall. Miraculously, the stone yielded to her touch and the cross remains even to this day. When Dioscurus returned and saw the new window, his furious temper overcame him. When Barbara heard him

54

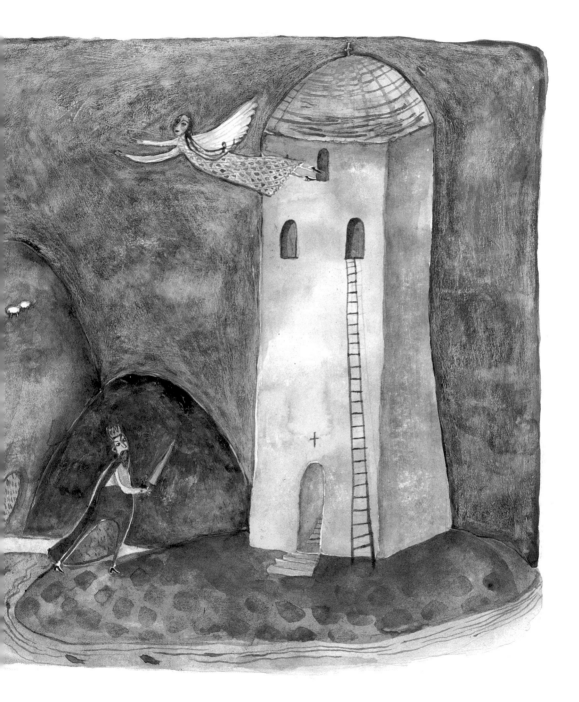

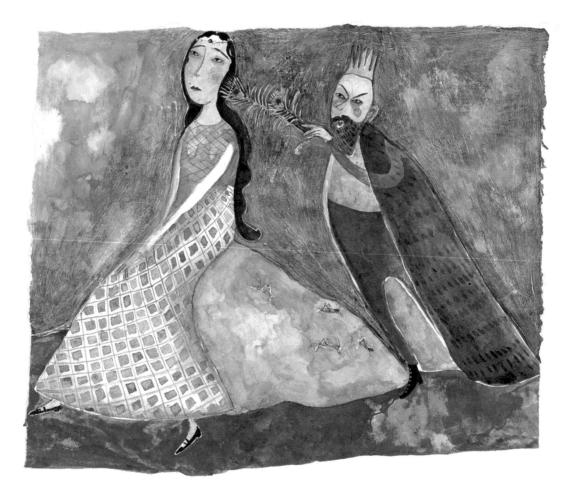

raging up the stairs, she prayed for wings. Just as he burst through the door, she flew out the new window and took refuge in a mountain cave nearby. A malevolent shepherd saw her flying and betrayed her whereabouts to Dioscurus. In retribution for this evil deed, Barbara turned the shepherd to stone and his flock into grasshoppers. Meanwhile, Dioscurus stormed up the mountain to find his daughter; when he discovered her, he began to beat her mercilessly with a whip of bull

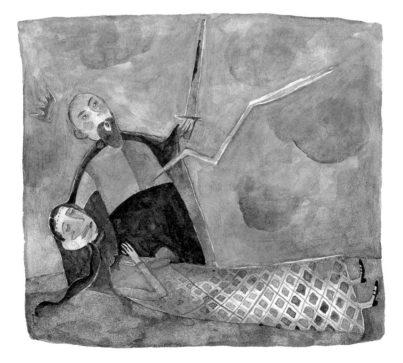

sinews, but as it touched her flesh, it turned into a peacock feather, which only tickled her. Further enraged by this failure, Dioscurus drew his sword and beheaded his daughter. Instantly, he was struck down by lightning.

Christians in Syria celebrate Saint Barbara between December 4th and Epiphany. Children are urged to be unselfish in her name, and they carry sweets, honey, and wheat anointed with rose water (symbolizing the memory of the deceased and the resurrection of their souls) to the town's unfortunates. If women fear that they are about to die without last rites, they may pray to Saint Barbara and she will intercede as a priest, giving the sacrament.

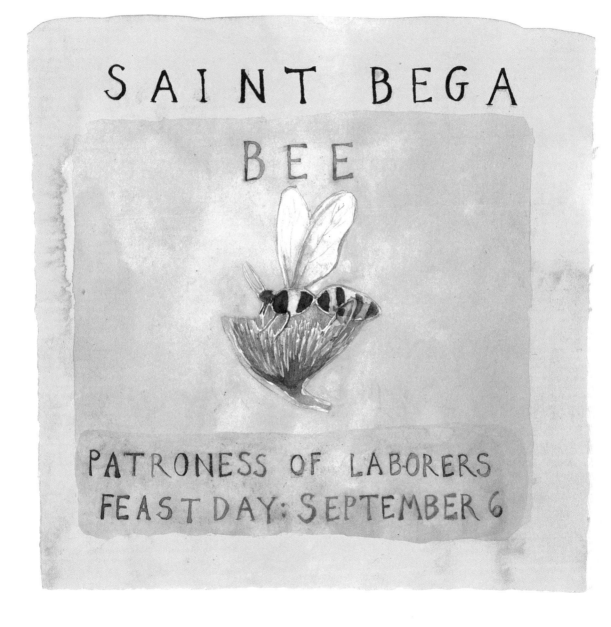

SAINT BEGA

BEE

PATRONESS OF LABORERS
FEAST DAY: SEPTEMBER 6

SAINT BEGA "BEE"

Feast Day: September 6
{PATRONESS OF LABORERS}

EGA, AN IRISH PRINCESS, received an engagement bracelet hung with a cross from the angels. Later, when her father suggested that she marry his friend, the king of Norway, she told the two men that she was betrothed to Christ and had taken a vow of virginity. As proof, she showed them her bracelet, but they only laughed. On the eve of her wedding, while her father and her betrothed were drinking themselves into a stupor, Bega sailed away on a piece of sod, wearing nothing but her bracelet. She washed up on the coast of Cumberland, where she lived as an anchoress and was fed by seagulls. Later she became a nun and helped build a convent. She made clothes for all the construction workers, and thus is venerated as patron saint of laborers.

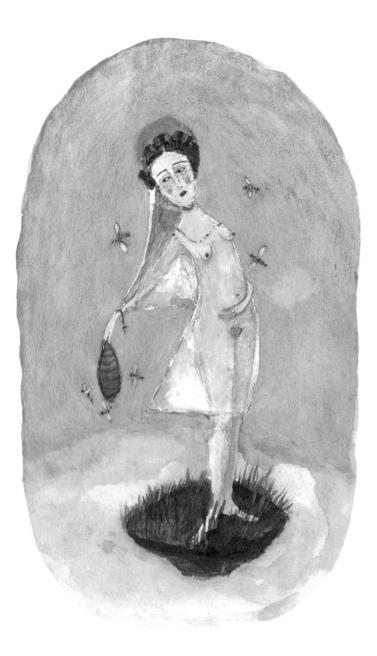

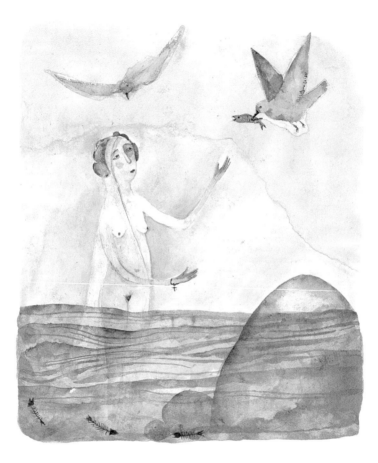

SAINT RIGID

THE BRIDE

PATRONESS OF MILKMAIDS

FEAST DAY : FEBRUARY 1

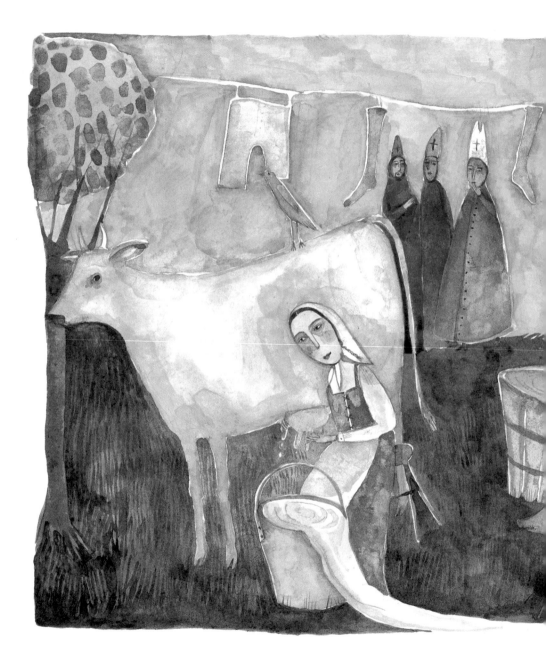

SAINT BRIGID

BRIGID WAS BORN AT sunrise in Connacht, Ireland, in the middle of the fifth century, daughter of a pagan chieftain, Dubtach, and his slave woman, Brocessa. Brigid grew up working alongside Brocessa as a milkmaid, milking the herd of white, red-eared cows and churning butter. While they worked, Brocessa secretly taught Brigid the tenets of the Christian faith, and the girl decided to take a vow of chastity.

Brigid was full of energy and performed an amazing number of miracles: she magically multiplied the supply of butter and turned her bath water into ale to help feed the poor. One day, seven itinerant bishops came by and Brigid had nothing to feed them, so she prayed as she milked her cows, and the milk flowed so copiously it formed a lake,

which is called the Lake of Milk even today. Wild ducks came to her call, and she taught a fox to dance. When she hung her laundry to dry, a ray of sun shone on it all day and all night, too, until it was thoroughly dry.

These miracles soon revealed her faith to the pagan Dubtach, who mistreated Brigid and her mother. When he decided that he wanted his daughter to get married, she began continuous prayers to become so

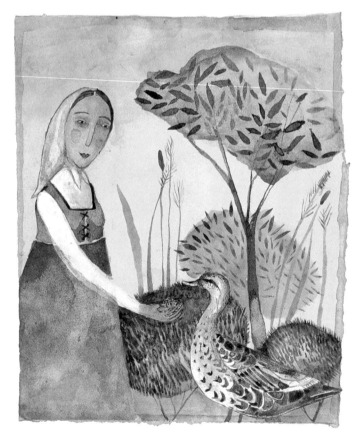

ugly that no man would want her and she could remain chaste. Her prayers were answered; one of her eyes grew enormous while the other one disappeared. With her disfigurement, Dubtach realized that he was never going to get her married and agreed to relinquish her to the nunnery at Kildare. As Brigid knelt at the altar to take her

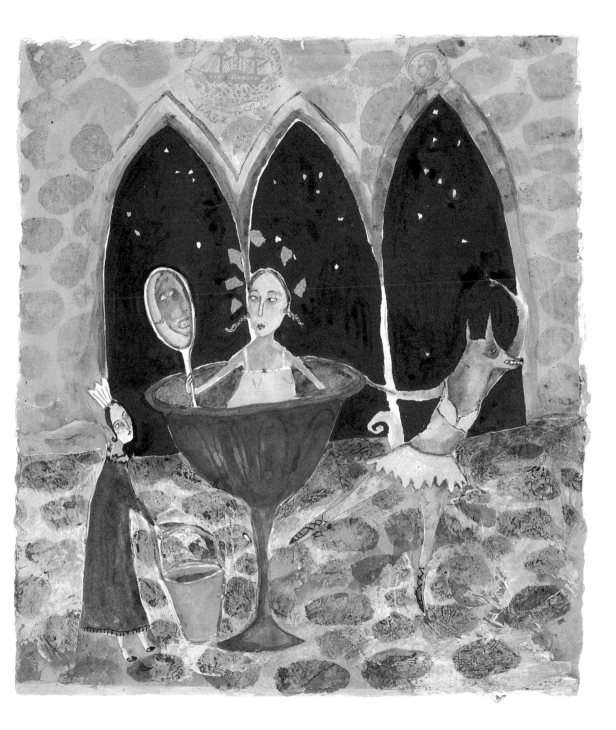

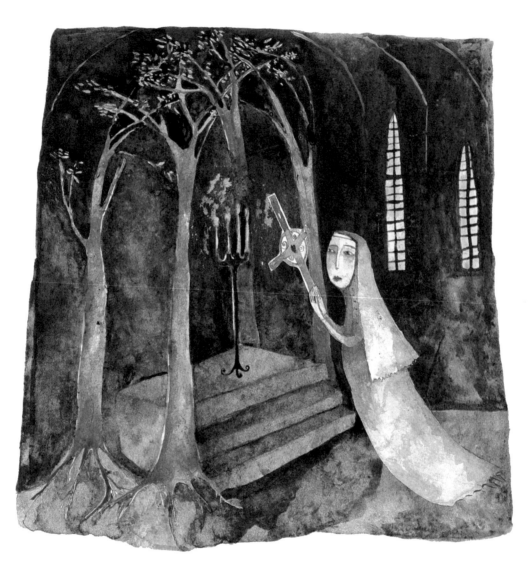

vows, her beauty was restored and the wood of the altar itself came to life again, growing green leaves as if it were a tree rooted in the earth. This very altar is still visited by the sick seeking new life. At Kildare, Brigid started Ireland's first religious community for free and bonded women who had been persecuted for their beliefs; it became a center for the making of illuminated manuscripts and other arts.

At her grave, where once no men were allowed, candles never stop burning. In Ireland, the eve of her feast day is called the Night of Crosses because it is celebrated by making crosses from straw, which ensure good harvests and prevent tooth-, ear-, stomach-, and headaches. A bed of brushes is set up on the hearth, in case Brigid needs a bed to rest in. Children carry a straw doll of Saint Brigid from house to house, collecting money in her name. Some Irish believe that her feast day is the first day of good weather because "she dipped her finger in a brook and off went the hen that catches the cold."

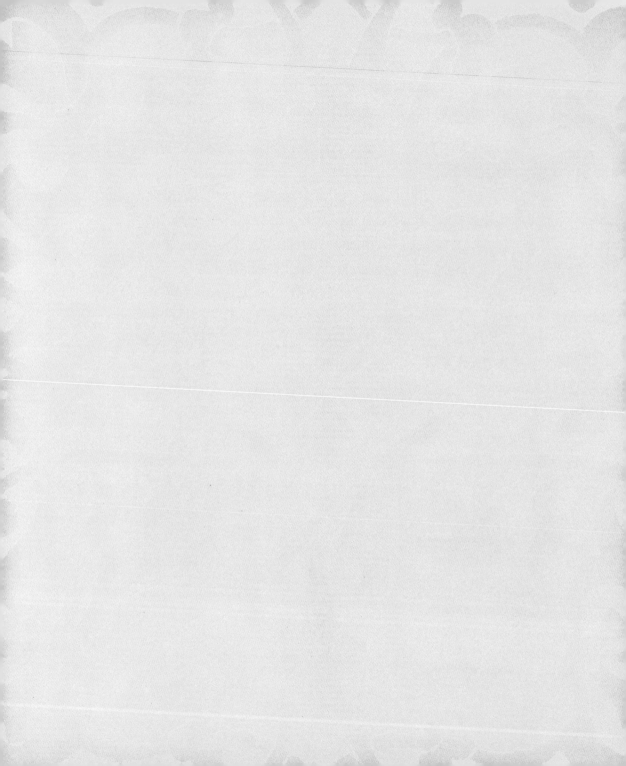

SAINT **C**HRISTINA
the Astonishing

PATRONESS OF PSYCHIATRISTS
FEAST DAY : JULY 24

SAINT CHRISTINA
THE ASTONISHING

Feast Day: July 24

{PATRONESS OF PSYCHIATRISTS}

CHRISTINA WAS BORN IN Brussels in 1150. The youngest of three daughters, she was orphaned at an early age. She suffered from epilepsy, and at twenty-one died from a seizure. However, at her funeral, she rose from her coffin and flew to the church rafters. The mourners all fled in horror except for her sister, to whom Christina complained of the offensive, garlicky breath of the congregation. She then explained that she had returned to liberate the souls she had seen in purgatory. For the rest of her life she had an acute sense of smell; she was often found hiding in ovens, on top of trees, or even balancing atop weathervanes to escape the odors of man. She soon came to be considered insane—or a witch—for her many odd habits: she handled fire with ease and swam in icy rivers, she prayed curled in a fetal position or balancing on one leg, she enjoyed being swung around on mill wheels.

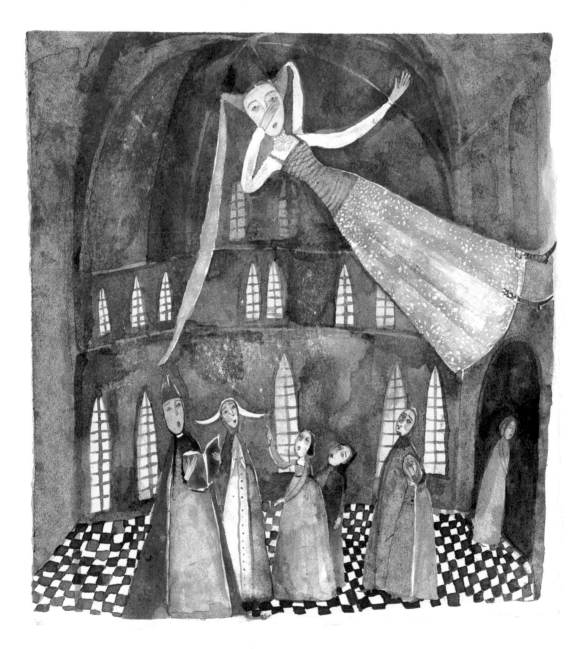

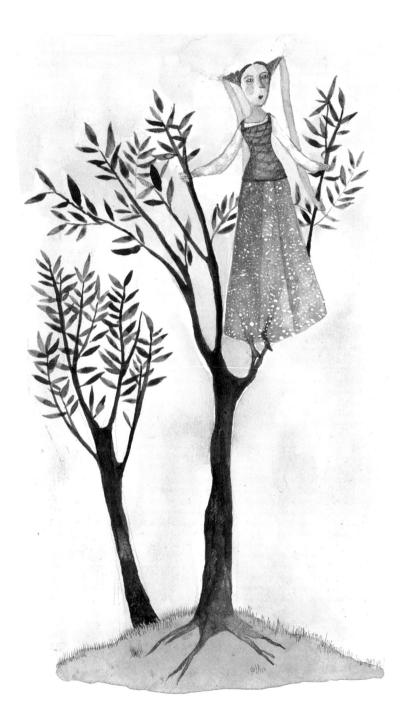

Eventually people tried to lock her up, but she always managed to free herself. Even with a broken leg, she once escaped from being chained to a pillar. Though she lived as a beggar, wearing torn rags, some towns-folk sought her out for advice. She spent her last years at the convent of Saint Catherine in Saint Troud and died at seventy-four.

SAINT

MARGARET

OF ANTIOCH

PATRONESS OF CHILDBIRTH

FEAST DAY : JULY 20

SAINT MARGARET OF ANTIOCH

Feast Day: July 20
{PATRONESS OF CHILDBIRTH}

MARGARET, WHOSE NAME MEANS pearl in Latin, was the daughter of a pagan priest, but her nurse, Theotimus, taught her about Christianity. When Margaret's father discovered their secret, the two women were banished from their home in Antioch and became wandering shepherdesses. A passing prefect, Olybrius, became entranced by Margaret's beauty, but she refused his advances. Humiliated, Olybrius had her bound to a rack and flayed until her bones lay bare and her blood flowed like a pure stream. Olybrius had to cover his eyes at the sight of so much blood, but he did not relent and ordered her to be thrust into a dank prison cell. It instantly filled with light when she entered.

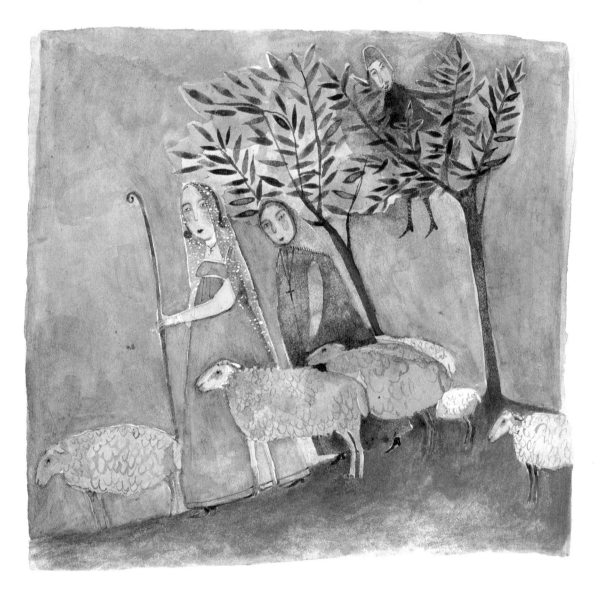

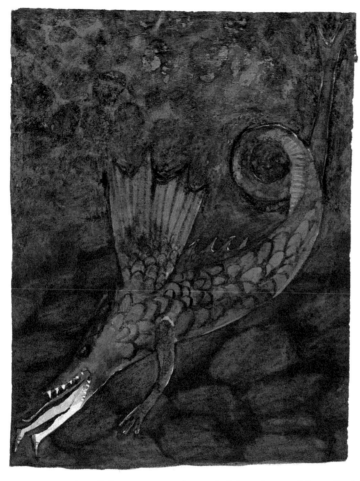

Satan soon came to visit her in the form of a hideous dragon. He swallowed her up whole, but inside the dragon's belly, Margaret made the sign of the cross, and he split in two. She emerged unscathed, which is why women pray to her during child-birth. Satan came to her again, this time possessing the body of a young man, but Margaret saw through his guise and knocked him down. Pinning him with her foot on his neck, she said, "Lie still, proud demon, under the foot of a woman." When the youth begged to be released from the spell of the Devil, she restored and freed him.

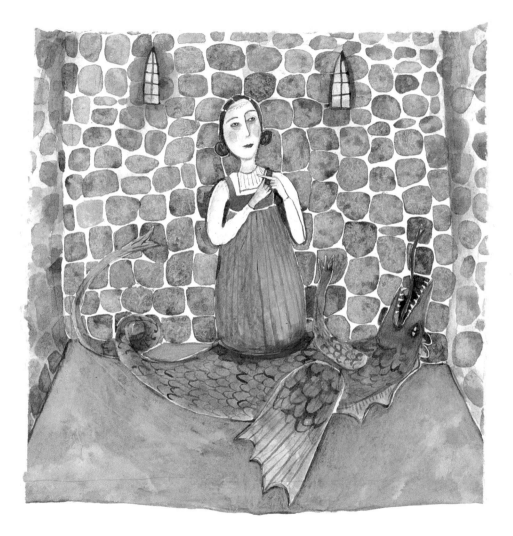

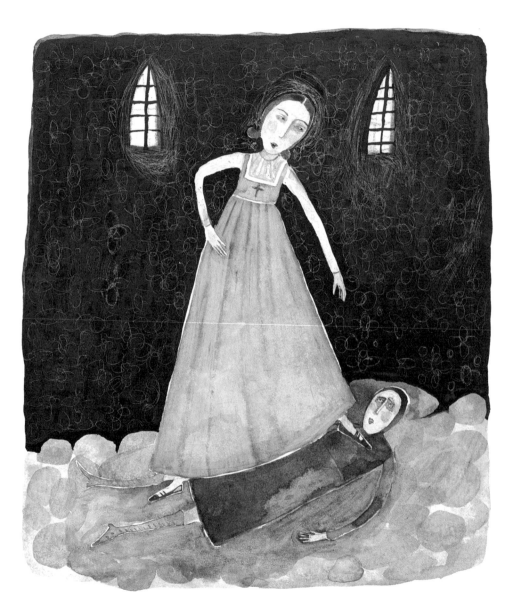

Olybrius visited her cell and commanded her to make a sacrifice to the gods. She refused, of course, and was burned with torches and plunged into boiling water. To the astonishment of the gathered crowd, Margaret stepped out of the vat unharmed. All five thousand spectators were converted, and Margaret was then beheaded.

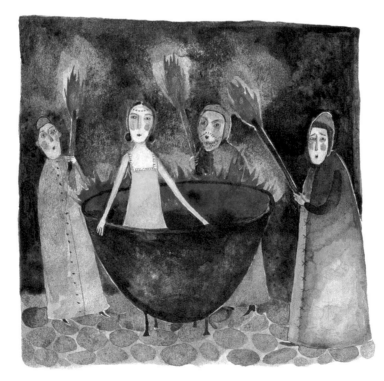

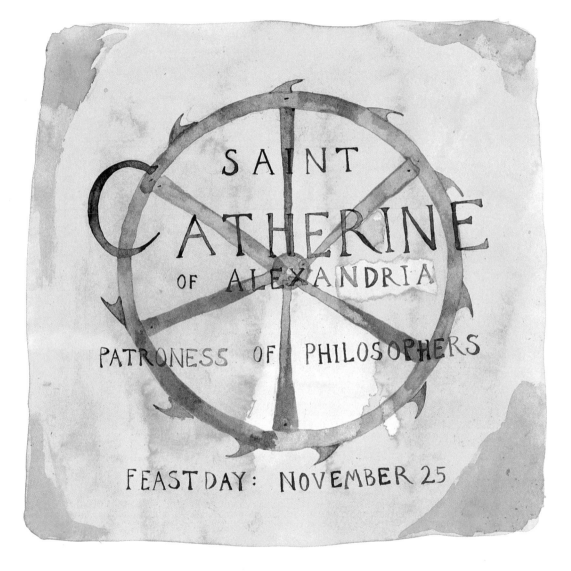

SAINT

CATHERINE

OF ALEXANDRIA

PATRONESS OF PHILOSOPHERS

FEAST DAY: NOVEMBER 25

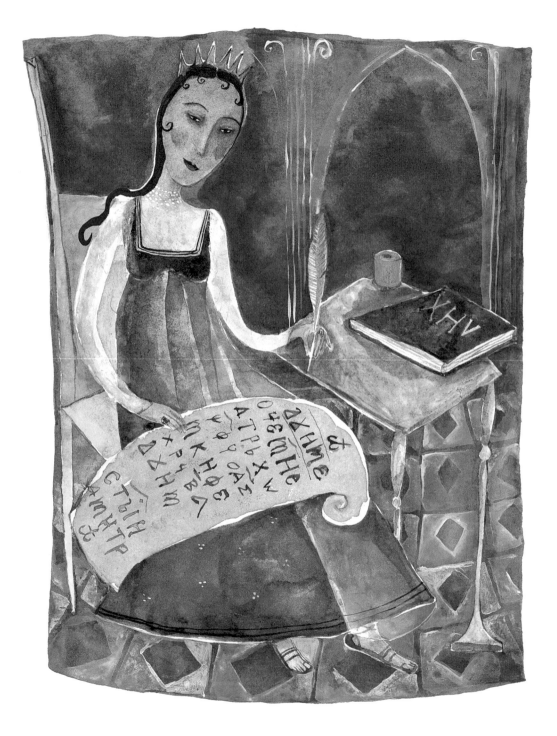

SAINT CATHERINE OF ALEXANDRIA

Feast Day: November 25
{ PATRONESS OF PHILOSOPHERS }

CATHERINE WAS THE ONLY daughter of King Costus of Egypt, a pagan. She was always studious, preferring books and philosophy to girls' games and chatter. Upon seeing an image of the Virgin and Child, Catherine was converted to Christianity.

One day when she was eighteen, Catherine was disturbed from her studies by the death cries of animals being sacrificed. While other Christians stood mutely by the sacrificial pit, fearing death if they spoke out, Catherine confronted the emperor, Maxentius, who presided over the altar of mangled animal bodies. Maxentius, overcome by her beauty and confused by her words, tried to argue, "No one ought to give thee belief, and so much less so since thou art but a frail woman." But he realized that his dim wit was no match for her intellect, and because he didn't want to be embarrassed in public, he summoned fifty pagan

scholars from near and far. When the assembled wise men learned that they had traveled only to debate "one miserable maid," they scoffed. Ultimately, they decided that they would condescend to refute the girl, but Catherine spoke with such wisdom and eloquence that she rendered all the men speechless, and, rather than argue further, they were converted. Maxentius was infuriated at this turn of events and ordered the scholars to be incinerated. Miraculously, none of their robes or hair burnt away. Maxentius was still infatuated with the

lovely Catherine, and now he begged her to become his queen. She refused, citing her vow of chastity, and he condemned her to prison without food or water. A dove brought Catherine celestial foods. Faustina, the emperor's wife (he was allowed more than one), visited Catherine in her cell and was also converted, so Maxentius tore off her breasts. When Maxentius himself came for a visit, he expected to see Catherine emaciated and near death. He was enraged to find her more radiant and ravishing than ever, and, in retribution, he concocted a special wheel, ever after called a "Catherine Wheel," studded with sharp knives and nails, and had Catherine tied against it. The idea was that the knives would revolve and cut through her, but as she was being stretched over the wheel, lightning struck it, sending sharp pieces into the crowd of four thousand onlookers, wounding and killing many of them. Catherine was unharmed, but soon Maxentius recovered himself enough to behead her. Milk, not blood, poured from her neck. Angels carried her body to Mount Sinai, where a nunnery was built in her honor. It is said that her relics exude an oil that heals weak bones.

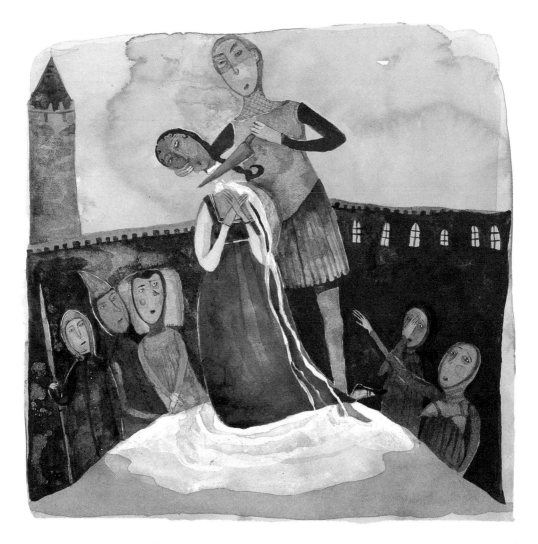

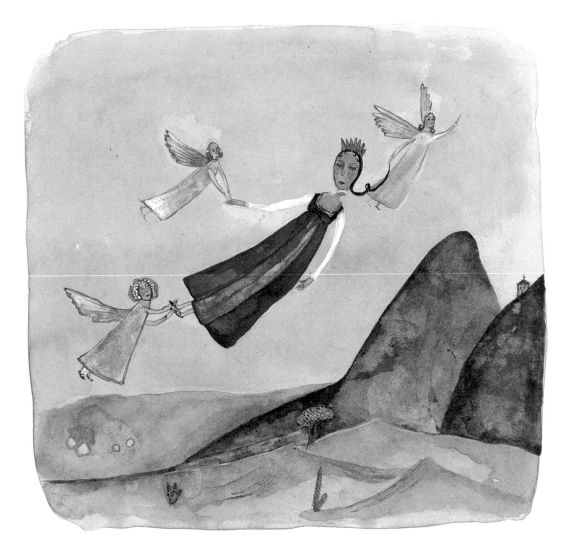

In France, on Saint Catherine's Day, unmarried women of twenty-five don paper caps to celebrate the possibility that they will remain maids. They jump over a lighted candlestick as well; if the woman's skirt catches fire, she will have misfortune for the following year.

SAINT

JOAN OF ARC

PATRONESS OF FRANCE

FEAST DAY : MAY 30

SAINT JOAN OF ARC

Born into a French peasant family in the seventy-fifth year of the Hundred Years War between England and France, Joan's childhood in the village of Domremy was fairly uneventful: she sewed and spun with her sisters, she ploughed the fields and herded the animals with her brothers, and she learned her faith from her mother. But at sixteen, Joan began to hear the voices of Saint Margaret and Saint Catherine of Alexandria, who counseled her to go to the dauphin Charles VII and help him reclaim the French throne. Joan's father, Jacques d'Arc, attempted to restrain her, but she managed to escape. First she went to her cousin, Robert Brandicourt, and asked him to assist her, but he only laughed at the idea that this young girl in a red peasant dress could help the dauphin. The voices of saints

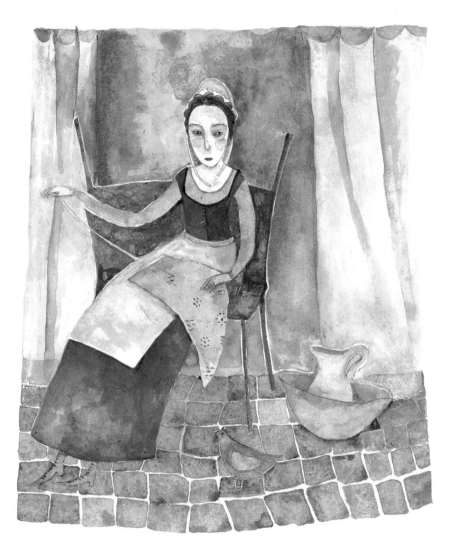

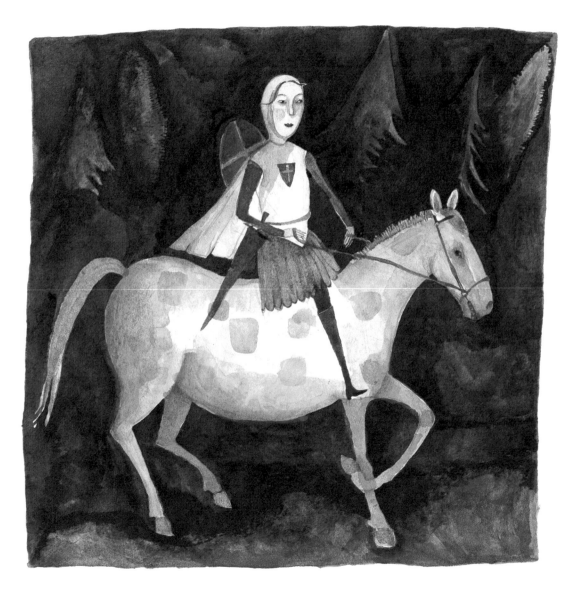

Margaret and Catherine redoubled their encouragement, and Joan persevered, pleading for Brandicourt's aid. At last, he lent her a horse, a sword, and a suit of armor. Joan cut her hair and rode off to the dauphin's palace, never to dress as a woman again.

Charles heard rumors of her approach and, in an attempt to prove her a charlatan, he dressed up as a jester when she entered his court. Joan immediately recognized him through his disguise and hurried

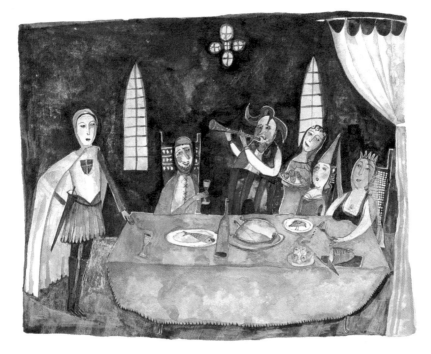

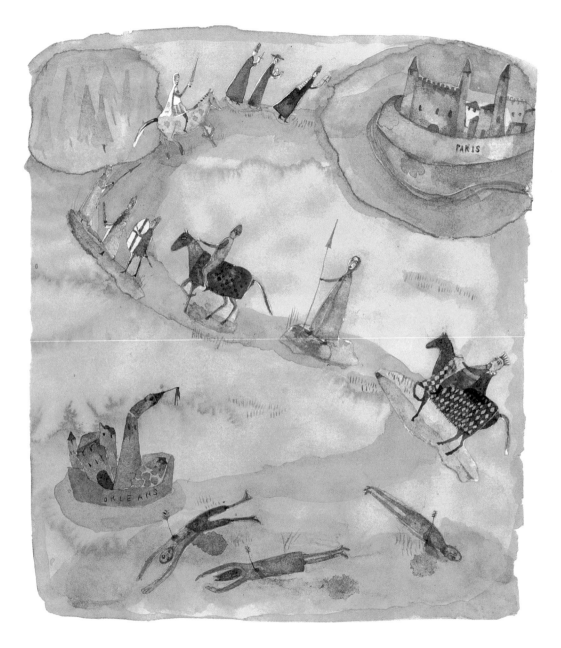

to him to explain her mission. Despite this proof of her power, the dauphin put her through many trials before he agreed that she should command his army. Clad in white armor and surrounded by chanting priests, Joan led the troops to battle while Charles and his other

generals lagged behind in a cowardly fashion. Pierced by arrows in her legs and breast, Joan nonetheless managed to recapture Paris and Orleans, but her victories ended when she was captured on the battlefield by the Duke of Burgundy, who sold her to the English. She was tried for heresy, witchcraft, and idolatry, and when she described the saintly voices that inspired her mission, she was con-demned to be imprisoned in a tiny cage, too small to stand in. Charles VII, though crowned king through her efforts, made no attempt to rescue her or intercede for her during

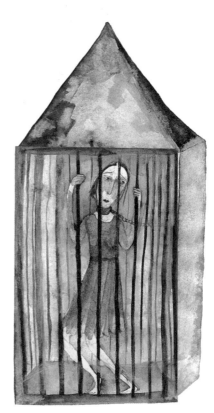

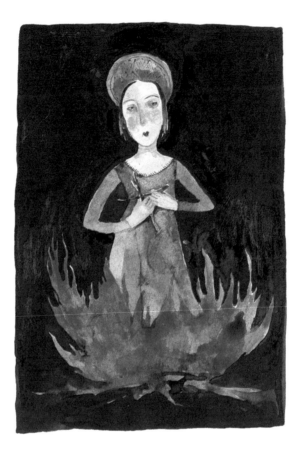

her year-long imprisonment. Finally, she was sentenced to be burnt at the stake. As she burned, she prayed aloud and held two sticks to form a cross; even the most hard-hearted onlookers shed tears at the sight. She died on May 30, 1431, at the age of nineteen.

Saint Uncumber
wilgefortis or Liberata

Patroness Against Men

Feast Day : July 20

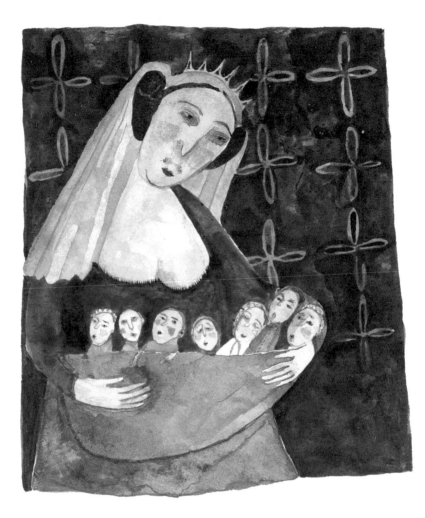

SAINT UNCUMBER, WILGEFORTIS, OR LIBERATA

Feast Day: July 20
{PATRONESS AGAINST MEN}

UNCUMBER, ALSO KNOWN AS Liberata and Wilgefortis, was one of seven daughters born simultaneously to the Queen of Portugal. Her father demanded that she marry the King of Sicily, and Uncumber prayed to be ugly so she could stay chaste. Accordingly, she grew a full beard and mustache. Her father, enraged at this demonstration of recalcitrance, ordered her to be crucified. From the cross, she promised to free all women from the encumbrance of men. Unhappy British housewives bring oats to her altar to feed the horses that will carry their husbands away.

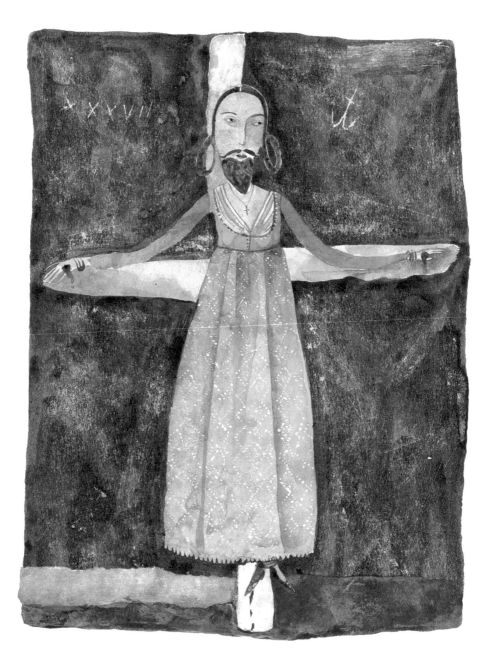